Ann-Marie James

Ann-Marie James

Proserpina

Ridinghouse

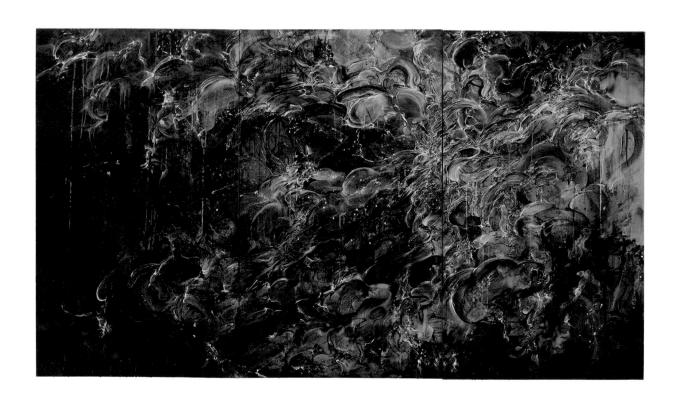

And in spoils of captive beasts 2012

Oil and acrylic on canvas
154.4 × 274.2 cm | 60¾ × 108 in

Ovid, Bernini and Ann-Marie James

Michael Bracewell

Of bodies changed to other forms I tell
Ovid, 'The Metamorphoses'[1]

The scene is chaotic: elemental in temper, angry, volatile, rushing and impatient – as though it were an unchecked force of nature. Against stormy blackness, a seeming torrent of arc-like smears of greying silver appears to cascade and break; flailing white tendrils that resemble clumps of river weed the colour of moonlight are caught in a restless current. Above this roaring, tumbled mass appear dirty bulbous shapes like banks of bruise-coloured cloud. Beneath, there are patches of impenetrable blackness, in mood akin to the void of darkness that appears to hang in the entrance of a cave. To one side the liquefied torrent seems to petrify into eroded strata of grey stone, which in turn can be seen to enter into an area of blackness that seems to be alive with malignant energy.

 Such is a first impression of a triptych by Ann-Marie James titled *And in spoils of captive beasts* (2012) – the title taken, along with those of all the paintings in her 'Proserpina' series, from Ovid's great poem of transformations, 'The Metamorphoses'. Approaching the painting cold, as it were, the viewer might encounter first its visceral communication of what feels to be an elemental disturbance of no small significance. The 'torrent' of white to silver grey, for example, that comprises a passage running loosely diagonal from the lower edge

of the middle panel to the top right-hand corner of the right panel. But on second look, one might be reminded of some form of magical rout - the movement and temper of the broiling, explosive forms seems one of commingled ebullience and fury. At the same time, there is the distinct impression of some transformative process, from liquid to solid perhaps; or as though some manner of lichen-festooned rock formation were being ravenously sheathed by a cascade of devouring, semi-sentient matter.

The cyclonic mood and movement of this large painting seems to convey, above all, the impression of primal activity: a power unleashed, or an omnipotent force let loose, unchecked. The viewer might imagine that this force is either natural or supernatural or climactic. The temper is never distant from that of a storm at sea, an astronomical phenomenon of unimaginable physical energy or the intimidating accumulation of an electric storm. But then there is always more, and in each 'Proserpina' painting, intensity of mood and density of composition fuse.

The gaze admits first the experience of complex, sprawling yet concentrate matter. Next, surges of plosive movement set against or within the darkness of a void or off-white, almost sickly luminescence. There seems to be a *psychology* at work within this mass: the forms and their endless successions of micro-transformations do not appear to be inchoate or brute. Rather, these routs and cyclones of apparently raw motion begin to possess a quality of agency: that they work according to the bidding of some power.

Studied more closely, in small sectional areas, James' 'Prosperina' paintings reveal the density of their form and movement to comprise many layers of gestural activity. They are compositions of immense sophistication, the dominating impressions of elemental force are made up of drips, splatters, translucent glazes, scuffs, smears, eddies, shadings, trails, swirls, rearing wave forms, rivulets and vertical, gauze-like curtains of paint - all in shades from black to white, all

6

simultaneously overlaid while seeming to mutate into chemical or geomorphic-like shapes. These metamorphoses of painted marks are likewise depicted with a vivid, three-dimensional sense of depth: the viewer feels as though they are looking deep into the innards of the painting, as though journeying through some manner of interior space. And the longer one studies the depths of these paintings' drama, the more one feels embroiled within their temper – their psychic reach.

The greatest surprise, however, is to discern – as in *And in spoils of captive beasts* – the undoubted form, in fragment, of a pair of human legs. This trace of human form occurs deep within the layers of the painting, visible beyond a succession of mean-looking drips of black paint and a semicircular arc of white; the extended left foot is obscured, as though splashing in a swiftly flowing mountain stream. This sudden particle of representational visual meaning might make the viewer consider that the entire composition is in fact shuttling between abstraction and figuration. Its identity is of necessity ambiguous, and that in part, or as a whole, comprises representational depictions of abstract or intuitively made forms. The tension of its temper lies in the manner, perhaps, that such a basis of the work is neither confirmed nor denied.

This series of paintings by Ann-Marie James is inspired by, and developed – one might write 'mutated' – from images of Gian Lorenzo Bernini's *Apollo and Daphne* (1622-25) and *Rape of Proserpina* (1621-22). This is seen in the accompanying body of James' drawings made directly on image plates she found in Richard Norton's *Bernini and Other Studies* (1914).[2] In their almost cinematic interpretation of highly dramatic scenes from Ovid's 'The Metamorphoses', these originating sculptures by Bernini comprise, on one level, figuration at its most uncompromising. We see Pluto carrying Proserpina down to the underworld, and her panic and despair are palpable. Daphne's transfiguration into a laurel tree is captured at the terrifying

7

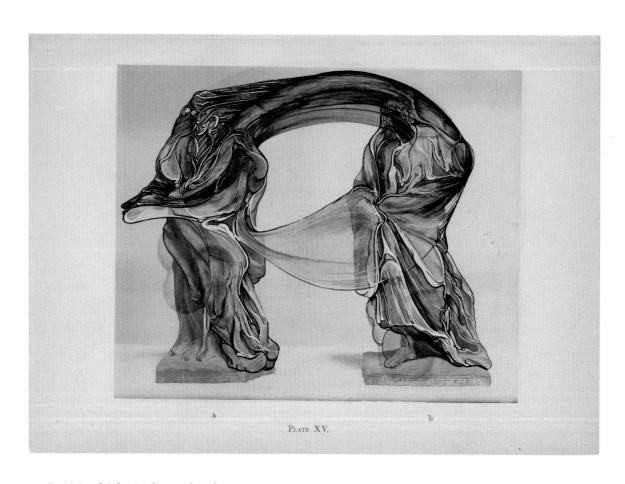

PLATE XV.

Bernini and Other Studies, Book 1, Plate xv 2013

Ink and acrylic on paper
19.1 × 27 cm | 7½ × 10⅝ in

moment of its instigation. The legend is given mesmeric plausibility by Bernini's depiction of the intent-pursuing god and the graceful yet despairing rise of the nymph's arms: the biomorphic mutation of her hair and hands into living foliage. The effect is immediate and shocking, conveying both the representational image of the scene, and in the god's intent yet cruelly impassive expression, an impression of absolute power as an archetypical force.

For the viewer unaware of the three-way relationship at work in these paintings and drawings, between Ovid, Bernini and then James, the intense complexity of each work proposes first, perhaps, a sense of awe and amazement that one might associate with the sublime: depictions of natural wonder that intimate infinity and, in doing so, evoke a sense of transcendence within the viewer. But then there is a dissonance, and a bat-squeak of disquiet that swiftly rises into an impression, one might think, of panic. *Into other bodies* (2013; p.28), for example, appears at once claustrophobic and cataclysmic. Through veils of what might be translucent ectoplasm, livid drips of black suggest the gradual disintegration of any solidity into molten form. The movement in the painting is simultaneously horizontal, vertical and internal; the myriad episodes of gestural activity appear to be occurring at the same moment, heavy with their own volcanic energy.

It is as though the viewer might be seeing a depiction of the omnipotence of the Graeco-Roman gods: that the restless urgency and seemingly auto-generative power of these abstract compositions might represent divine and supernatural raw power. It is the 'stuff', so to speak, of magic and enchantment. And there is also, in this series of paintings, the dialogue between figuration and abstraction which both reveals the processes of painting and proposes a tension between coherent and inchoate forms. It is as though James were intuitively yet minutely following a series of decisions and interventions, unfolding a narrative of abstraction that is at once mysterious and driven by the DNA of its own visual logic.

Likewise the drawings within this group of works are made upon century-old plates of classical sculpture, some depicting twin images of statues and relief carvings linked by what look like twisted and stretched lengths of gum or ectoplasm. Elsewhere, the 'found' statuary in the images is shrouded in semi-translucent folds and swirls of whiteness – akin to being partially wrapped in a diaphanous shroud. Other drawings present a more developed metamorphosis of the found image into its abstract form: fine, hair-like ink lines first mummify and then extrude from the classic figure, which appears to be gradually engulfed in the transformative process. The imagery is omnivorously fecund, seeming to devour and obliterate even as it transforms the source image.

These drawings might give the viewer some insight into the manner in which James works with image – literally describing the process of transformation from figuration to abstraction. On the one hand, the image becomes a figurative, representational depiction of a coherent object becoming an abstract form: a painting of an instant of metamorphosis. On the other, the 'extrapolation' of the form of the found image, with stretched, circular, enfolding, shrouding gestural forms, suggests the beginnings of a greater process: an eruption of visual meaning into lava-like flows and combustions.

In this manner, James engages directly with Ovid's central theme of transformation. The appearance and disposition of the gods, too, is faithfully represented: the constant transmutation of phenomena – as in the tale of Pentheus and Bacchus, where we read how, at the appearance of the god:

> ... ivy creeping, winding, clinging, bound the oars and decked the sails in heavy clusters.... The men leapt overboard, all driven mad or panic-stricken. Medon's body first began to blacken and his spine was arched into a curve. 'What magic shape is this?' cried Lycabas...[3]

10

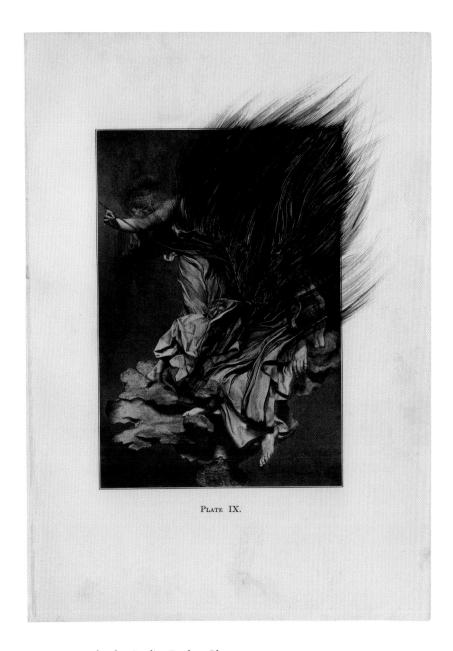

PLATE IX.

Bernini and Other Studies, Book 11, Plate IX 2013

Ink and acrylic on paper
27 × 19.1 cm | 10⅝ × 7½ in

This series of paintings and drawings by Ann-Marie James seems also to depict, in one sense, 'magic shape'. This may be the magic used by gods to exert their will, imagined in its raw form as a cataclysmic energy source, omnipotent and all consuming. Or it may be the more terrestrial business of mutating a figurative image into an abstract form, and then pursuing the pictorial 'temper' of the released abstraction – as one might regard the rolling moods of an electrical storm. The power of 'transformation' is fundamental to both archetypical myth and to the processes of painting and drawing, and on one level these paintings and drawings perform an analysis of the art-making process: what separates visual meaning from pictorial chaos? They are animated with drama, dense with mood and atmosphere, filled with a sense of the fantastical and the mythological. Yet as images released entirely to operate according to their own internal mechanisms, these paintings and drawings describe and reveal the changing of forms with beguiling verve, elegance and formidable intensity.

1 Ovid, 'The Metamorphoses', A.D. Melville (trans), Oxford University Press Oxford, 1986, p.1.
2 See: Richard Norton, *Bernini and Other Studies*, The Macmillan Company, New York, 1914.
3 *Ibid.*, p.71.

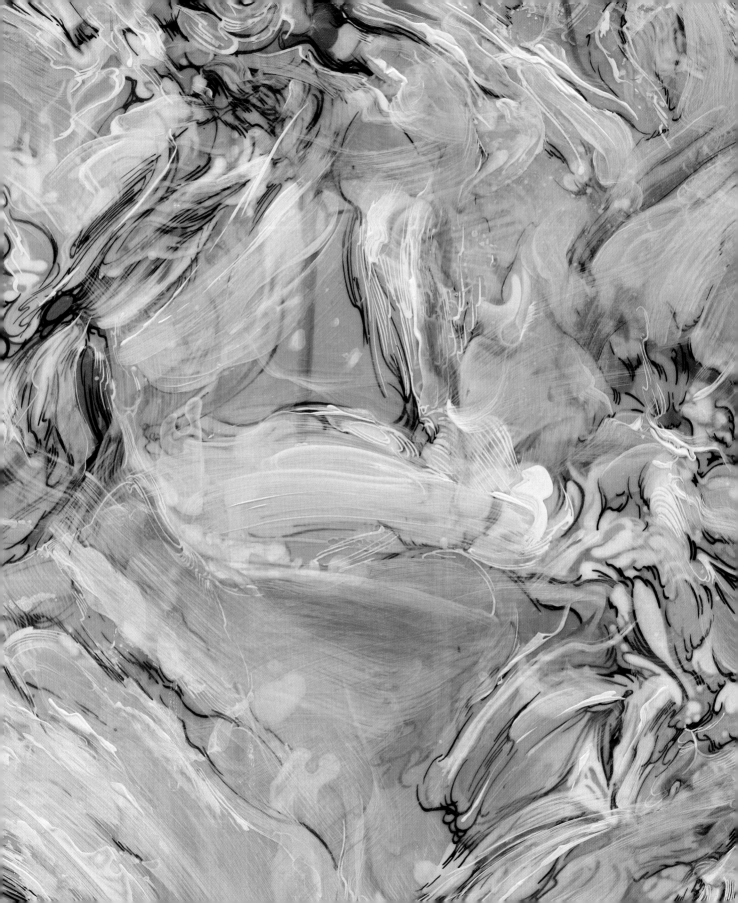

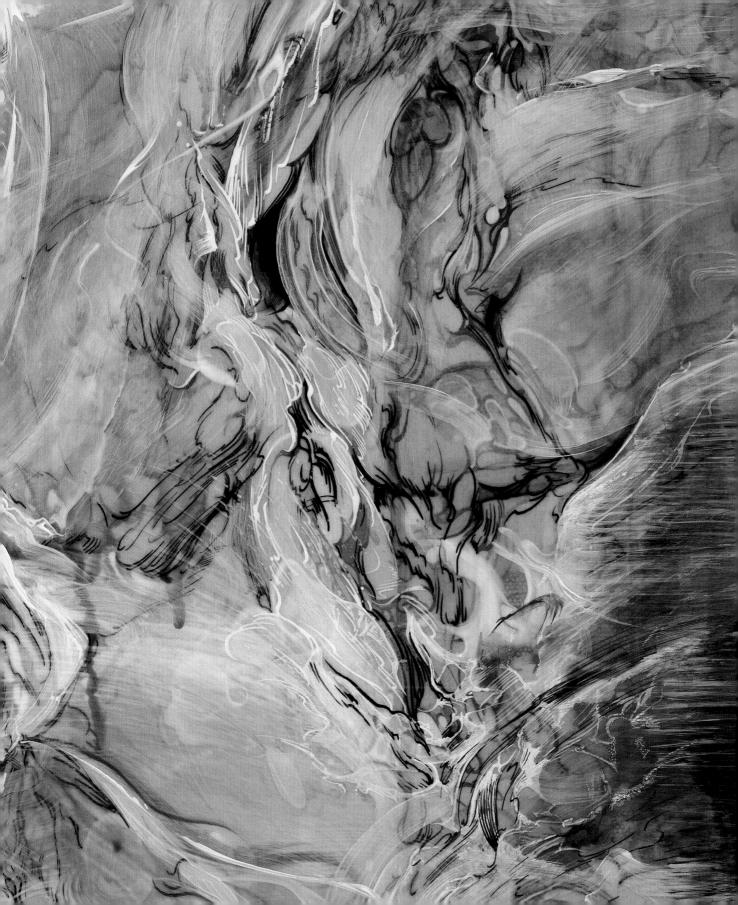

All other places 2013

Oil and acrylic on canvas
100 × 70 cm | 39⅜ × 27½ in

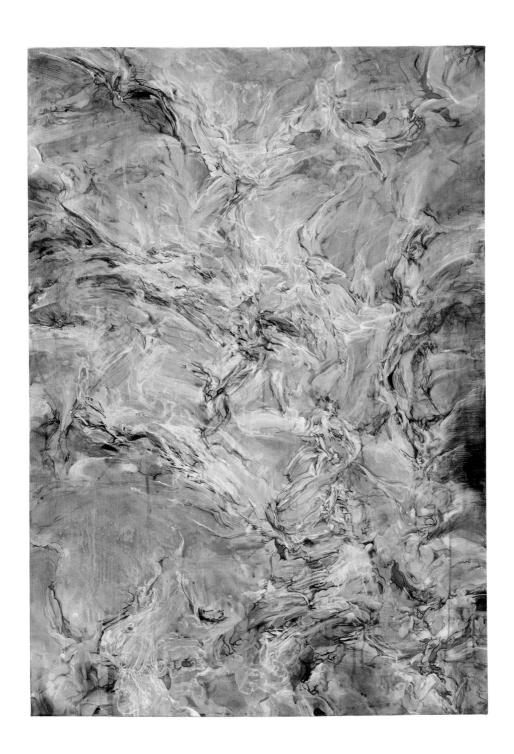

Besotted and doomed 2013

Oil and acrylic on canvas
100 × 70 cm | 39⅜ × 27½ in

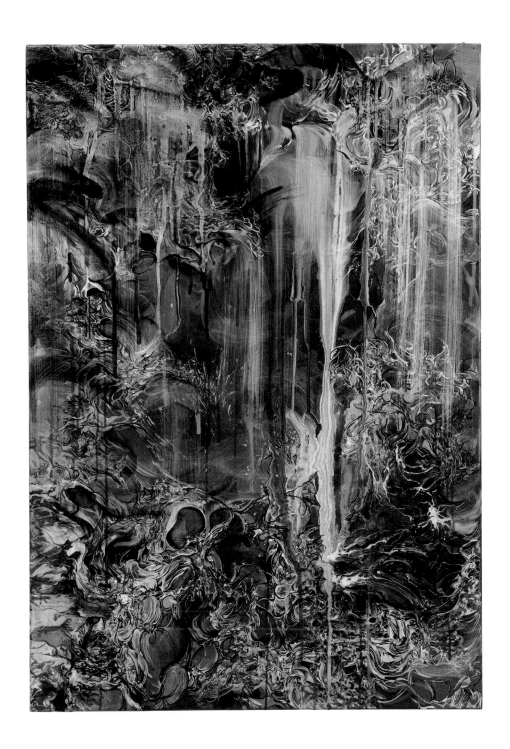

Flat on his back 2013

Oil and acrylic on silk
100 × 70 cm | 39⅜ × 27½ in

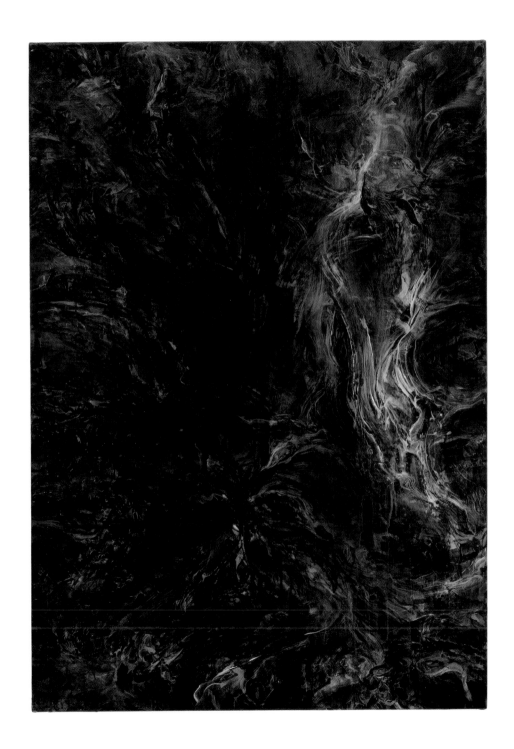

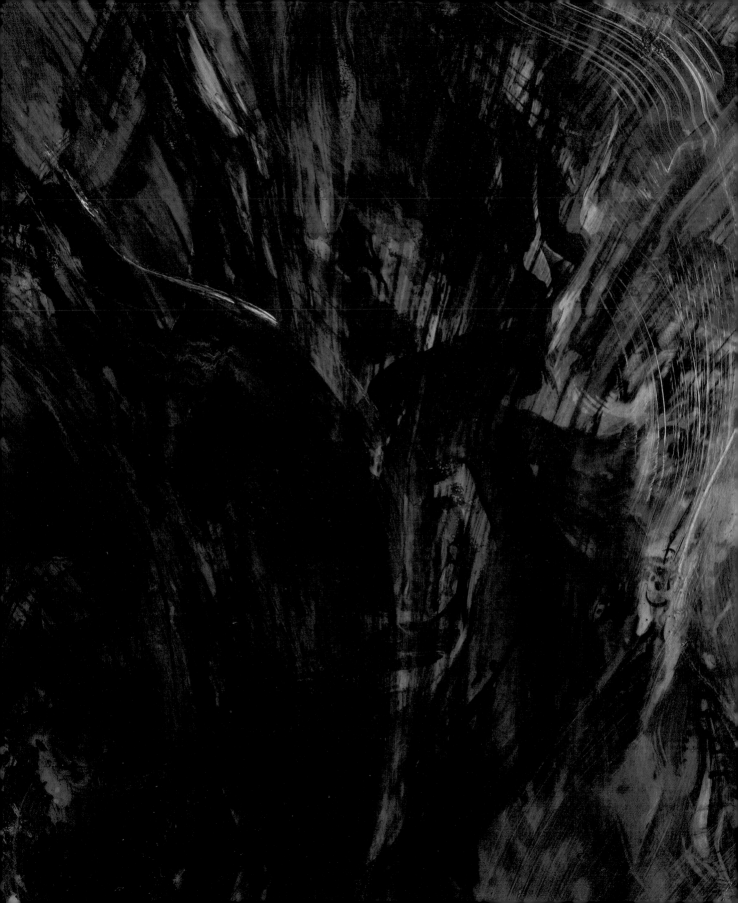

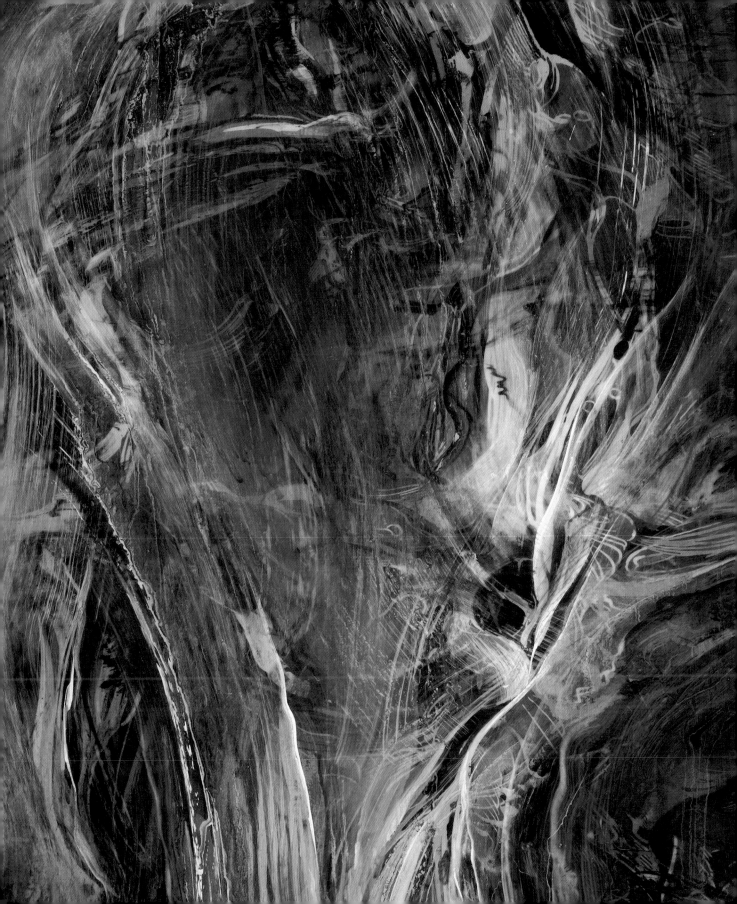

Always spring 2013

Oil and acrylic on silk
100 × 70 cm | 39⅜ × 27½ in

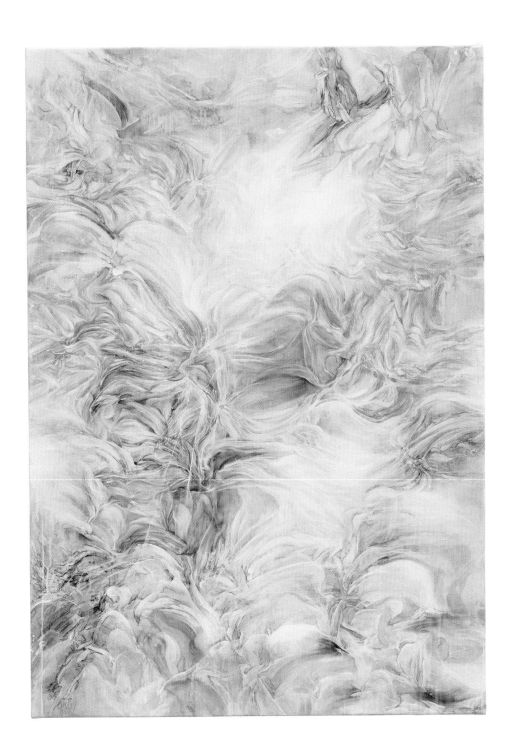

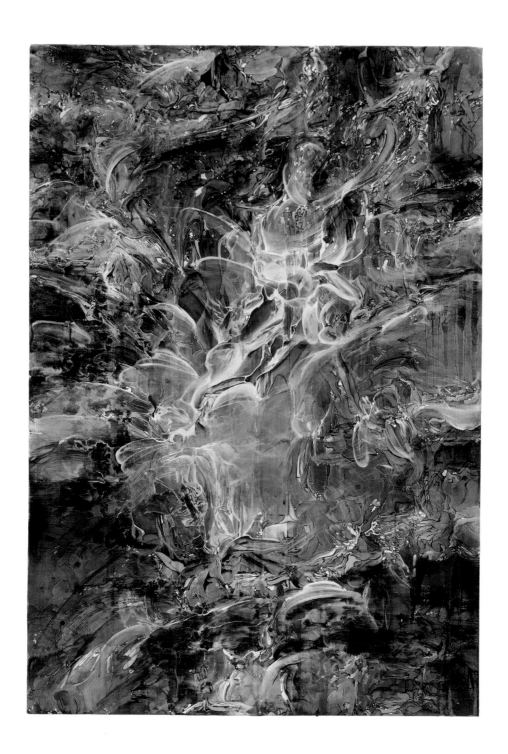

A bandit, a ruffian 2013

Oil and acrylic on canvas
100 × 70 cm | 39⅜ × 27½ in

Into other bodies 2013

Oil and acrylic on canvas
100 × 70 cm | 39⅜ × 27½ in

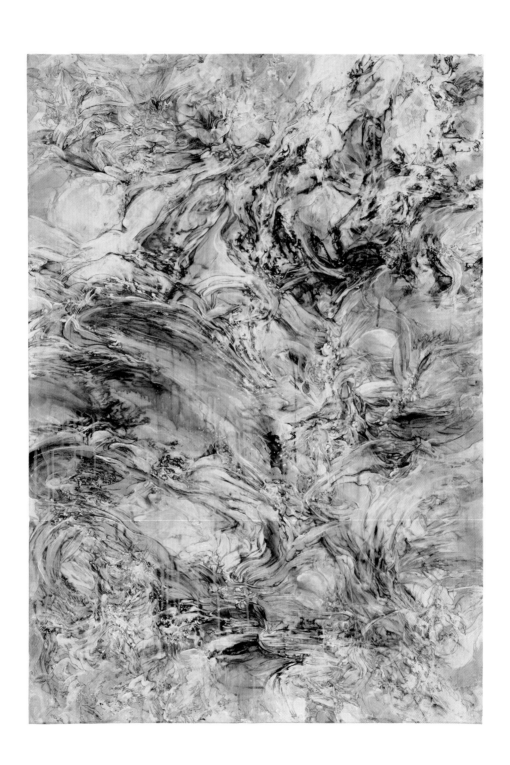

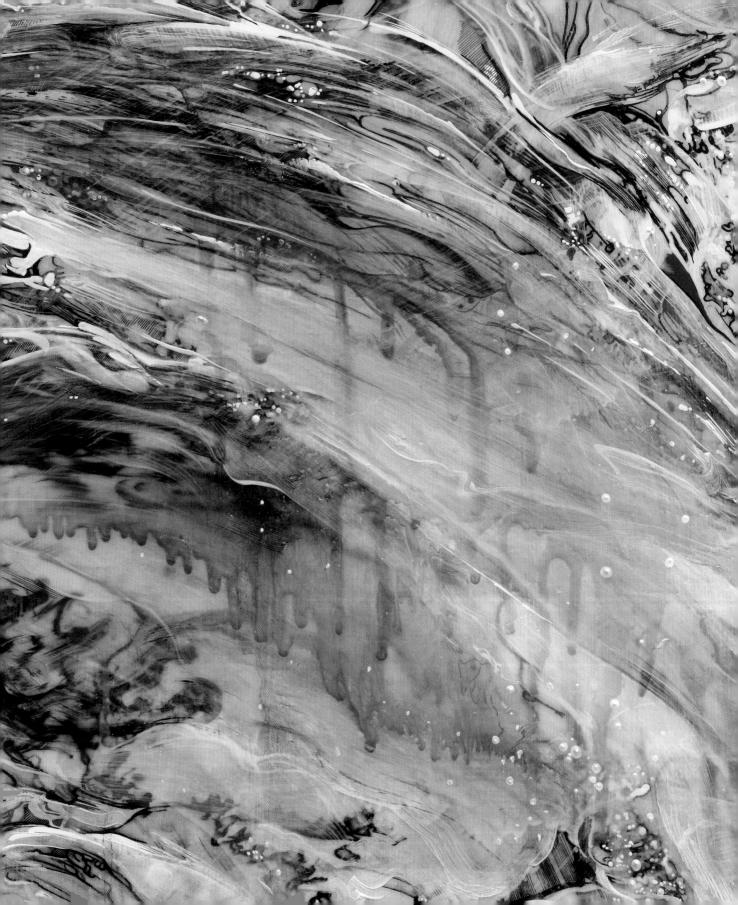

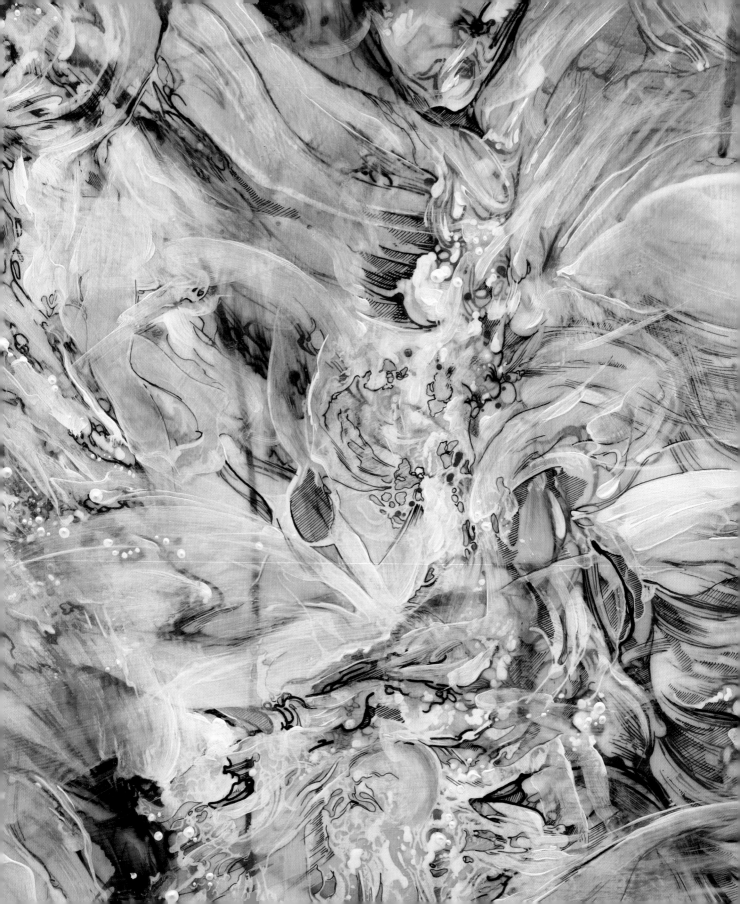

Published on the occasion of the exhibition
Ann-Marie James: *Proserpina*
at Karsten Schubert, London
6 March–5 April 2013

Published in 2013 by Ridinghouse
5–8 Lower John Street
Golden Square
London W1F 9DR
United Kingdom
www.ridinghouse.co.uk

Distributed in the UK and Europe by
Cornerhouse
70 Oxford Street
Manchester M1 5NH
United Kingdom
www.cornerhouse.org

Distributed in the US by
RAM Publications
2525 Michigan Avenue Building A2
Santa Monica, CA, 90404
United States
www.rampub.com

British Library Cataloguing-in-Publication Data:
a full catalogue record of this book is available
from the British Library

ISBN 978 1 905464 73 9

Ridinghouse Publisher: Doro Globus
Editorial Assistant: Louisa Green

Designed and produced by Mark Thomson
Set in Lyonnais
Printed by die Keure, Belgium